Inq
8 ...

U/G
1.99

D0904349

HAUNTED VICKSBURG

ALAN BROWN

Haunted
America

Published by Haunted America
A Division of The History Press
Charleston, SC 29403
www.historypress.net

First published 2010

All images are courtesy of the author.

Manufactured in the United States

ISBN 978.1.59629.926.9

Library of Congress Cataloging-in-Publication Data

Brown, Alan, 1950 Jan. 12-
Haunted Vicksburg / Alan Brown.
p. cm.
Includes bibliographical references (p.).
ISBN 978-1-59629-926-9
1. Haunted places--Mississippi--Vicksburg. 2. Ghosts--Mississippi--
Vicksburg. I. Title.
BF1472.U6B7443 2010
133.109762'29--dc22
2010028167

CONTENTS

Contents

ACKNOWLEDGEMENTS

First of all, I would like to thank my wife, Marilyn, who never complains when I suggest that we visit a haunted town or city. In addition, I would like to thank Greg Jones for his invaluable technical advice. I would also like to thank Jim Gorney, Shirley Smollen and Skip Tuminello for their very helpful interviews. Finally, I would like to recommend Vicksburg Historical Ghost Tours for a good overview of the city's ghost stories.

INTRODUCTION

Vicksburg, like most river ports, is a city firmly grounded in its past. Ever since La Salle paddled down the "Big Muddy" in 1682 and claimed the entire Mississippi Valley, Vicksburg has been a hotly contested prize. Located high on a series of bluffs overlooking the horseshoe bend of the Mississippi, the area that was to become the city of Vicksburg passed through the hands of the Spanish before the United States finally purchased it from the Choctaw Nation in 1801. For forty-seven days in 1863, General Ulysses S. Grant tried to wrest Vicksburg from Confederate control. Lieutenant General Pemberton and his forces finally surrendered on July 4, 1863. Today, over one million tourists visit the Vicksburg National Military Park and the city's beautiful antebellum neighborhoods.

Even though Vicksburg will probably always be identified with the Civil War era, like Gettysburg, not all of its attractions involve Greek Revival architecture and

magnolias. Barges loaded with over 300,000 tons of cargo pass through Vicksburg every day, traveling along the same routes steamboats used in the 1800s. The Miss Mississippi pageant, which is held in Vicksburg every July, casts a glamorous sheen over the old river city. Thousands of people travel to Vicksburg to try their luck at the Ameristar Casino every year.

Still, Vicksburg is a city that treasures its history. Its lovingly preserved antebellum homes, many of which are now bed-and-breakfasts, transport visitors back to a time when gentlemen in top hats and frock coats and ladies in hoop skirts promenaded down the city streets. Vicksburg is also a city that celebrates its past through its ghost stories. In these tales of slaves, wealthy planters and Civil War soldiers, one can detect the core values—courage, determination, endurance, love of family and self-sacrifice—that have sustained the residents of Vicksburg for over two centuries.

ANCHUCA

The beautiful antebellum mansion at 1010 East First Street is located in one of Vicksburg's oldest residential sections. The Greek Revival mansion was built in 1830 by a local politician named J.W. Mauldin. In 1837, a wealthy planter named Richard Planter moved into the mansion from Oaken Grove Plantation in Claiborne County. Archer enlarged the mansion to accommodate his large family, consisting of his wife, Ann, and five daughters. He named the house Anchuca, a Choctaw Indian word for "Happy Home." In 1840, a coal and ice merchant named Victor Wilson purchased Anchuca. Seven years later, he added the columns in the front of the house to reflect the Greek Revival style. Anchuca became the first columned mansion in Vicksburg.

People say that Wilson enjoyed watching his barges float down the Mississippi River. During the Siege of Vicksburg, Anchuca was used as a field hospital. In 1868,

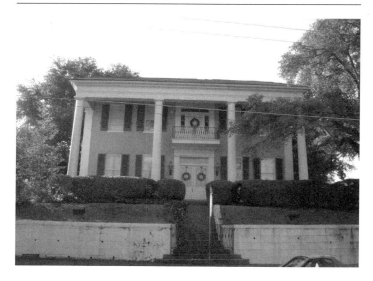

Anchuca.

Joseph Emory Davis, Jefferson Davis's older brother and mentor, moved into Anchuca. While visiting his brother in 1869, following his release from Deeral Prison, Jefferson Davis spoke to friends from Anchuca's balcony. This was his last public speech. Joseph Emory Davis and his granddaughter lived at Anchuca until his death in 1870 at the age of eighty-seven. A number of different families lived in Anchuca in the late nineteenth and the early to mid-twentieth centuries. In 1936, Anchuca was owned by Mrs. William Joseph Vollor when it was surveyed by the American Historic Buildings Survey.

Anchuca is now one of Vicksburg's most popular bed-and-breakfasts. Most of the architectural elements, such as the heart pine floors, fireplace mantle and crown moldings, are original. However, none of the original furnishings remains. Period antiques, representing the late 1700s to the mid-1800s, give guests and tourists an idea of how Anchuca would have looked before the Civil War. Some of these antiques include an American Empire secretary of rosewood mahogany from the 1830s, a Victorian mirror from the 1860s, a chandelier of gilded bronze from 1780, a U.S. cavalry sword from 1860 and two rare prints by Audubon from 1832. One of the most interesting features is Wilson's coal-burning fireplace. Anchuca was one of the first homes in Vicksburg to use coal for heat. One holdover from the past that is only occasionally on display is the ghost of Archie Archer.

In an interview with author Sheila Turnage, innkeeper Lovetta Byrne said, "The ghost story is that supposedly there was a man that lived here, who had a daughter. And she was dating this guy that he did not want her to date." According to Kathryn Tucker Windham, author of *13 Mississippi Ghosts and Jeffrey*, the owner of the house was Richard Archer. His youngest daughter, Archie, was a lovely, headstrong girl who fell in love with Josh Melvin, the son of Richard Archer's overseer. One day, Archer caught the couple sitting on a bench under a cypress tree. Josh stood up and asked Archer for his daughter's hand in marriage. Furious, Archer struck Josh in the face with his riding whip and ordered him to leave. He then turned to Archie and told her that he could

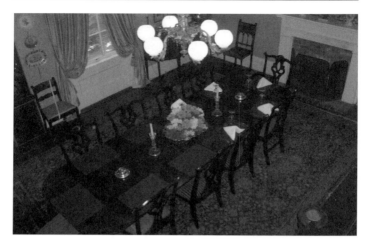

The fireplace mantle in Anchuca where Archie Archer took her meals.

not allow her to marry someone so far beneath her. With tears streaming down her face, Archie vowed never again to eat at her father's table. Until her father's death in 1867, Archie had all of her meals served on the mantle above the fireplace in the parlor.

The first sighting of Archie Archer's ghost took place in 1966. According to author Kathryn Tucker Windham, one morning, the Lavenders' teenage daughter walked into the parlor and saw a young woman about eighteen years old standing by the mantle. The girl was pretty, and she was wearing a brown dress. Archie's ghost has been seen many times since then, either in the parlor or in the dining

room. Loveta Byrne said that one of the previous owners saw Archie's ghost sitting in an antique chair in front of the fireplace. Byrne never saw the ghost, but she did feel an unsettling presence in the parlor in 2000.

In July 2009, I interviewed one of the cooks at Anchuca. The young man, who wished to remain anonymous, said:

> One night last year, a friend of mine and I were getting ready down here for lunch. We looked at the top of the stairs, and we saw this lady in a nightgown walking into one of the master suites upstairs. There was nothing abnormal about her. We asked the house manager who was staying in the house that night, and she said, "Nobody." We checked all of the rooms upstairs, but we couldn't find anybody there. Both of us saw her.

A few days later, a couple staying in a suite upstairs took pictures of the room before they left. When they returned home and looked at their photographs, they were surprised to see a little girl sitting in the rocking chair. This was the same master suite the cooks had seen the strange woman enter.

Archie Archer's persistent presence inside Anchuca has generated a number of explanations. Does she remain in the house in the hope that Josh will return for her someday? Could it be that she cannot rest because of the unresolved conflict between her and her father? Or is her ghost simply a residual spirit whose energy intermittently reenacts the most defiant act of her life?

THE BALDWIN HOUSE
RESTAURANT

Built in 1890, the Baldwin House is located at the intersection of Crawford Street on the same block as Pemberton's Headquarters and the Balfour House. In the early 2000s, California natives Bruce and Marion Baldwin visited the Baldwin House with the intention of transforming it into a bed-and-breakfast. In an interview with Unexplainedfiles.com in April 2003, Marion said that they were walking through the house when she felt something brush against her hair. Her initial fear escalated when she realized that there were no birds inside the house that could have flown against her head. Bruce, who is a paranormal investigator in his spare time, had always wanted to live in a haunted house. When he and Marion purchased the Baldwin House and started their restaurant, it became clear after just a few months that Bruce's dream had come true.

Bruce has concluded that he and his wife share the Baldwin House with seven spirits. Only three of them,

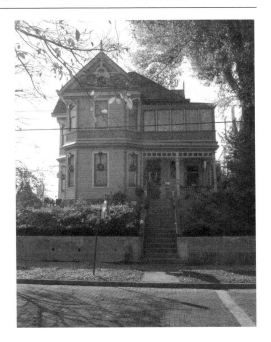

The Baldwin House Restaurant.

however, have distinct identities. One of the resident spirits is the ghost of a woman who lived on the second floor of the Baldwin House in the 1920s. Dubbed Aunt Gertrude by the Baldwins, her ghost has usually been seen standing on the top of the stairs, wearing long, flowing black skirts with white trim. People on the first floor claim to have heard the light footsteps of a woman walking on the second floor when no one was up there. Aunt Gertrude's ghost has never been sighted on the first floor.

The Baldwins refer to another female entity in the Baldwin House as "the funeral lady." The ghost's black, old-fashioned clothes give eyewitnesses the impression that she is in mourning. A waiter had a very frightening encounter with the funeral lady. One day, he was working in the front room when he heard a knock on the door. To his surprise, a woman wearing a nineteenth-century dress was standing on the front steps. Assuming that she was a docent from one of the nearby tour homes, the waiter invited the woman inside. He led her to a table and turned around to ask her if the location was all right. The woman was nowhere to be found.

The third spirit who seems to have a distinctive personality is called Uncle Charley. Unlike the other two ghosts, Uncle Charley prefers to remain outside. He is usually seen peeking into one of the windows on the first floor.

The other ghosts inside the Baldwin House are not so clearly defined. On several occasions, Marion has seen a man standing on the staircase. He always wears a black suit and hat. The Baldwins have also heard low mumbling sounds coming from the front room and the bedroom. The sounds always stop when Marion or Bruce walks in the room.

The Baldwins have learned to live with the seven ghosts in their restaurant. A collection of ghostly photographs taken inside the house is proudly displayed on the first floor. A substance identified by paranormal investigators as ectoplasm is clearly visible in several of

the photographs. Bruce and Marion even invited the Unexplained investigative team to spend the night in their house in 2003. The only hard evidence the researchers collected was an EVP, which, when played in reverse, said, "Hey, have a nice day."

The fact that Bruce has been investigating the paranormal phenomena for years does not entirely explain why he does not mind living and working in a haunted house. At least one of the ghosts in the Baldwin House is exceedingly polite. "I started to go out the front door," Bruce said, "and I reached down for the knob…and the knob turned by itself, and the door opened."

THE BB CLUB

The B'nai B'rith Literary Association building was constructed at 721 Clay Street in 1887. The first hints of the elegance that awaited guests within were the marble steps and the hand-carved limestone exterior. The front rooms on the first floor were paneled in mahogany. The billiard room on the first floor was resplendent with its wood-paneled walls and wooden floors. The dining room on the first floor featured crown molding and magnolia windows.

The BB Club, as it came to be known in the late 1890s and early 1990s, was known throughout the South for the lavish parties that were thrown there. A beautiful staircase led guests to the grand ballroom, which could serve as many as five hundred people. One side of the room was graced with tall arched windows; beautiful wall mirrors could be found on the other side. For over seventy years, the BB Club was known from Memphis to New Orleans

as the ideal venue for balls, lectures, banquets and wedding receptions. In 1960, the BB Club was sold to the City of Vicksburg. For thirty-five years, the old building housed the Vicksburg Police Department. Before long, the police discovered that the beautiful old building contained more than just memories.

In his book *Ghosts along the Mississippi*, Jim Longo says that the Vicksburg Police Department was haunted by the ghost of a man who possibly died in a fire at the BB Club. Officer Fannie Tonth said that when she first started working at the police department, another female officer told her that the second floor was haunted. When the woman admitted that she would never walk up the stairs to the second floor by herself, Officer Tonth felt shivers creep up her spine. One night, she was working the front desk by herself when she was overcome by a sense of fear. Recalling words that her mother had told her when she was a little girl, she used the first name that came into her head and told the ghost, "Willie, you don't scare me!" Standing up to "Willie" enabled her to make it through the rest of the night.

Although Willie left Officer Tonth alone that night, she believes that he did make his presence known on other occasions. She said that on one occasion, one of the officers turned off her typewriter and went to the bathroom. When she returned, her typewriter was back on. She turned off the typewriter and went to a different part of the building. At the end of her shift, she returned to her office, and the typewriter was on again.

Officer Tonth said that she could tell when Willie was around by the strange sounds that he occasionally made. Several times, officers reported hearing someone use the drinking fountain in a room where no one was present. Officer Tonth said that some people heard disembodied footsteps walk down the hallway, climb the stairs and move along the second floor. A lieutenant who was on duty at the desk heard someone walking around upstairs. His curiosity was piqued because he knew he was the only person in the building at the time. A few minutes later, he heard someone working in the back room. The phantom footsteps continued all night long. The lieutenant said that other people who worked the night shift claimed to have heard doors slamming and floorboards creaking. One person even heard what he described as the sound of someone working in the kitchen.

In 1995, the police department moved to a new building, and the former B'nai B'rith Literary Association site was purchased by local businessmen, who set about to resurrect the BB Club. They undertook an extensive renovation project, which involved restoring the old building to its turn-of-the-century grandeur and installing a modern kitchen. Today, the BB Club houses a catering service called Storycook Favorites, which uses the grand old building as a backdrop for class reunions, showers, bridesmaids receptions, rehearsal dinners, banquets and luncheons. One wonders if spirits of the paranormal variety are served up at the BB Club along with the usual fare.

CEDAR GROVE MANSION

John Alexander Klein was a wealthy planter and businessman. Klein was fully aware of the danger of investing all of his time, effort and funds in a single business venture. To insulate his fortune against the vicissitudes of the market and the national economy, Klein diversified, dabbling in banking, lumber and cotton. He was also a skilled jeweler and architect. In 1840, while on a business trip to New Orleans, Klein met a lovely fourteen-year-old girl named Elizabeth Bartley Day. He was so smitten by the girl that he began construction of a three-story Greek Revival mansion while waiting for her to turn sixteen. In 1842, Klein married Elizabeth and presented her with Cedar Grove Hall as a wedding present. She was sixteen years old, and he was thirty.

The Kleins spent their honeymoon in Europe, where they set about purchasing furnishings for their beautiful new home, such as Bohemian glass for the doorway,

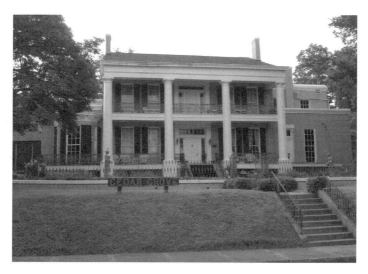

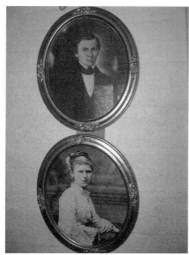

Above: Cedar Grove Mansion.

Left: John and Elizabeth Klein.

paintings by renowned artists, Italian marble fireplaces and French Empire gasoliers. Several pieces of furniture, now on display in the Grant Room, were made by renowned artisan Prudent Mallard. After Elizabeth and John returned from Europe, they resided in the poolside cottage while the finishing touches were added to Cedar Grove. The mansion was completed in 1852. Before long, Cedar Grove became one of the showplaces of Vicksburg. A number of southern celebrities, including Jefferson Davis and William Tecumseh Sherman, danced in the ballroom.

In 1862, John rode off to fight with the Confederacy, leaving behind his very pregnant wife. During the forty-seven-day Siege of Vicksburg in 1863, General Sherman moved Elizabeth behind the Union lines to have her baby because she was a relative. In gratitude, she named her infant son Willie in honor of the general. He also converted her home into a Union hospital to ensure that it would survive the war. Nevertheless, Cedar Grove was hit several times during the bombardment. In fact, cannonballs are still embedded in the wall and floor of one of the parlors. After Vicksburg's surrender, General Grant slept in the four-poster bed in the master bedroom. Some of Sherman's soldiers were still living on the first floor when the Kleins moved back into their home a few months later.

Unlike many wealthy planters, John Klein retained his house and property after the Civil War because of the money he kept in a hidden safe and used to pay his taxes.

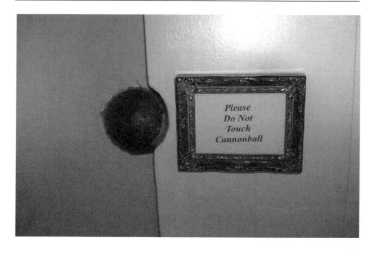

The cannonball embedded in the parlor wall at Cedar Grove Mansion.

Members of the Klein family continued living in Cedar Grove Hall until 1919. In 1983, Estelle and Ted Macky bought the old house and the surrounding property. By that time, Cedar Grove had suffered greatly from neglect and from the passing of time. They then undertook an extensive project to restore the old mansion and the carriage house to their former glory. They also bought the houses across the street, which they converted into cottages. Today, Cedar Grove Mansion and Inn occupies five acres. The Mackys have gone to a great deal of effort and expense to make the old home like it was when the Kleins lived there. Perhaps this is the reason some people say the Kleins have returned—in spirit form.

The hole made by a cannonball in the parlor floor at Cedar
Grove Mansion.

The paranormal activity at Cedar Grove Mansion and
Inn can be explained, at least in part, by the large number
of deaths that have occurred there. John and Elizabeth had
ten children, only six of whom lived to adulthood. Two
infants died of childhood diseases. A two-year-old daughter
died of yellow fever. Their sixteen-year-old son, Willie, was
killed in a hunting accident. He and a friend had returned
from hunting and were sitting on the back step of the house.
While the pair was talking, Willie's friend accidentally
knocked over his rifle. The loaded weapon went off, hitting

Willie in the chest. The story goes that Willie somehow managed to climb up the stairs to the second floor. When he reached the top of the stairs, he collapsed and died on the spot. No one knows for certain how many wounded Union soldiers died inside the mansion in 1863, when it served as a hospital.

John Klein's ghost reminds the staff that he is still around in a couple of ways. Peggy Shaeffer, manager at Cedar Grove, told author Sylvia Booth Hubbard that his ghost seems to favor the gentlemen's parlor, where he entertained his male friends over a century ago. Every night, before he went bed, he sat in the gentlemen's parlor and smoked his favorite meerschaum pipe. Ms. Schaeffer and other members of the staff have smelled the strong aroma of pipe tobacco in the room on many occasions, usually in the afternoon. Ms. Shaeffer also said that a photograph of the present owners has been placed on a small table in the gentlemen's parlor. On occasion, she has walked into the room and found the photograph turned upside down. When she turns it right side up, the picture will again be upside down the next time she returns to the gentlemen's parlor.

The spirit of a young girl who died in Cedar Grove in 1919 has also been sighted in the old mansion. She is a restless ghost who walks up and down the stairs. Although she has only been seen by people who believe in ghosts, both believers and skeptics have heard her footsteps creaking on the steps, often at night. Ted Mackey told author Sheila

The staircase leading to the second floor at Cedar Grove Mansion.

Turnage that one night, guests who were staying in a room at the top of the stairs were kept awake all night by the sound of small feet running up and down the stairs.

The ballroom, which was the scene of so many gala events generations ago, was also a place of horror. In the early twentieth century, one of the owners was a physician. One day, his daughter, who had had a history of mental illness, dropped by the house for a visit. The next day, the sound of a single gunshot echoed through the house. Her father was shocked to find that the girl had shot herself in

The ballroom at Cedar Grove Mansion, where the young woman killed herself.

the head in the ballroom. Over the years, guests and staff have seen the hazy figure of a girl standing in the ballroom. A few people have heard the sound of a gunshot and glass shattering in the ballroom. They have run into the ballroom, expecting the worst, but neither a gun nor a body has ever been found.

Peggy Schaeffer said that a number of guests and employees have seen shadowy figures walking up the stairs. One of the staff members heard the stairs creak at the same time that the specter was descending the stairs. In the early 1990s, a former manager was standing on the first floor when he saw

a woman walk a few steps down the stairs and then disappear. Immediately, he recognized the woman as a former tour guide who had died a few months before. She was wearing the same type of antebellum dress that she had worn during the pilgrimage tours. The manager was so frightened that he ran out the back door. The most common ghostly noises are the crashing sounds that shake the entire house.

Ms. Shaffer and other employees have also heard a variety of eerie sounds in the old house. On many occasions, she has heard doors slamming and the sound of someone running down the stairs. She said that at night, she has heard someone walking across the gallery when everyone was asleep. One night, she was working at the front desk when she heard someone scream and then fall down the stairs. She rushed over to the stairs to see how badly the person was hurt, but there was no one there. A few months later, she felt someone run past her. At the same time, the flowers sitting on a table also moved.

Several guests have had strange experiences in the basement where the wine cellar used to be. In 1863, Sherman's army used the wine cellar as a morgue for the soldiers who died in the house. In 2007, a couple staying in the morgue room turned off the lights in the library at the top of the spiral staircase and went to bed. They had almost fallen asleep when they noticed that the light was turned back on in the library. The husband sleepily made his way up the spiral staircase, but no one was there.

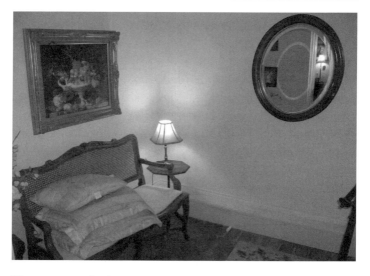

The guest room in the "morgue" of Cedar Grove Mansion.

The ladies who work at the desk and in the restaurant also give tours to guests. One of these ladies, who wished to remain anonymous, has had a number of strange experiences in her three years at Cedar Grove Mansion. In 2008, she was working in the bar and restaurant area when she saw someone walk in the back door. She immediately stopped what she was doing and went to the front desk. When she walked into the lobby, no one was there. She became frightened when she looked all over the house and realized that she was the only one there at the time.

A few days later, she was working at the front desk one morning when, out of the corner of her eye, she

saw a man walk past her. He was wearing a suit from the nineteenth century. He went to the end of the short hallway and turned left into the bar area. She followed him to the bar to tell him that the bar was not open yet. The bar was completely empty.

The tour guide said that guests have also had bizarre encounters in Cedar Grove. One evening, she was giving a tour of the house on the first floor. After about twenty minutes, she led the group up the stairs to the second floor. They were walking down the hallway when a woman who was spending the night stopped the tour guide. She said that something strange had happened to her right after she checked in and walked up to the room. She opened the door and noticed immediately that the bed was made, but the indentation of two tiny hands was clearly visible. The bed was high, so the guest deduced that the child's ghost had tried to push herself up on top of the bed.

The tour guide admitted that sometimes she has brought her small daughter to the house on the days when she is working. However, people have heard the laughter of small children and the sound of a ball rolling down the stairs on days when she left her daughter at home. One day, she and her daughter were at the front desk when they heard a door open on the second floor. The tour guide knew that no one was staying up there at the time, so she and her daughter ran up the stairs to investigate. They found a room with the door open, but no one was inside.

Cedar Grove Mansion changed owners a number of times in the twentieth century. At least one family is said to have left because the ghosts were too disruptive. The current owners have accepted the presence of the guests who never check out. In fact, in October, the tour guides insert ghost stories into their tours. One can say that the ghosts are considered to be just as much a part of Cedar Grove Mansion as the marble mantles, crystal chandeliers and huge Tuscan columns supporting the galleries at the front and rear of the mansion.

CHRIST EPISCOPAL CHURCH

Christ Episcopal Church was founded in 1828 with the support of the rector of the Episcopal church in Natchez. For the next eleven years, the members held services in borrowed buildings while they struggled to raise funds for a permanent structure. Their dream was finally realized in 1839, when construction of the wood and brick structure was completed at 1119 Main Street. Bishop Leonidas Polk laid the cornerstone. The church floor was sixty feet long and forty feet wide. The cast-iron church bell was transported overland from Philadelphia, Pennsylvania, and then floated down the Mississippi by steamboat or barge to Vicksburg. Cypress timbers were used to reinforce the bell tower. A sixty-foot cypress timber runs under the floor of the church. Trusses made of pecan support the roof. The choir and organ were located on a balcony in the rear of the church. The original windows were most likely clear glass panes.

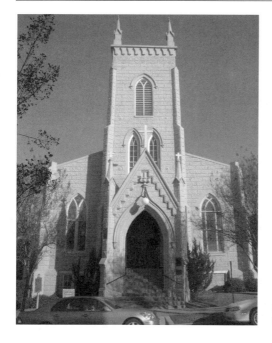

Christ Episcopal Church.

The early history of the church was wracked with hardship. The membership of the church was decimated by the yellow fever epidemics that ravaged the area in the nineteenth century. In fact, one of the first rectors of Christ Episcopal Church, Reverend Patterson, died during the yellow fever epidemic of 1835. The church took a strong stand against the influx of riverboat gamblers who descended on Vicksburg in the 1840s. In 1843, a mêlée erupted after the leaders of the church ordered the gamblers to leave the city. Dr. Bodley, a member of Christ Episcopal Church, was shot and killed.

During the Siege of Vicksburg in 1863, the bombardment of the city by Federal gunboats damaged the church and destroyed the rectory. A new rectory was erected ten years later. The church was almost destroyed once again by a schism that erupted after Reverend W.W. Lord was replaced, in his absence from Vicksburg, by Reverend Henry Samson. In 1870, Reverend Lord and a faction of the church formed the Church of the Holy Trinity. In 1953, a massive tornado swept over the city and destroyed part of Christ Church. Only one of its stained-glass windows from the nineteenth century survived the devastation.

Today, the members of Christ Episcopal are justifiably proud of their church's rich history. For years, though, rumors have circulated throughout the city that at least part of the past might still be present at Christ Episcopal Church. A few years ago, a new priest who had been warned about the possibility of experiencing an overwhelming feeling of sadness at the lectern walked into the sanctuary just before the Sunday worship services and addressed the invisible entity directly: "I'm here now, and you're not welcome. You can stay here as long as you don't bother anyone." Several months later, a tour group walked through the sanctuary hoping to detect the otherworldly presence in the church. No one experienced any feelings of depression inside the church.

The paranormal activity inside the old church seems to have ceased. Perhaps the priest's determination to be the primary authority within the church—aside from God, of course—intimidated the intrusive spirit for good.

DUFF GREEN MANSION

In 1856, a local businessman named Duff Green built the elegant mansion at 1114 First East Street as a wedding present for his new wife, Mary Lake Green. For the remainder of the decade, the Greens threw some of the city's most lavish parties at their beautiful home. The good times came to a sudden end for the Greens—and Vicksburg—during the Siege of Vicksburg. The Duff Green Mansion survived the destruction of the war because Duff and Mary offered up their home as a field hospital to the commanders of both armies. The Union wounded were treated on the top floor of the house; injured Confederate soldiers were cared for on the main floor. The kitchen was converted into a makeshift operating room. Trace evidence of the home's medical service is readily apparent in the bloodstains on the polished floors. The house was struck five times by cannonballs before Mary raised a yellow flag, signifying that the house was being used as a hospital. The

damage wrought by one of the cannonballs can be seen in the ceiling beams of one of the rooms.

To avoid being killed in the bombardment, the Greens lived in caves dug in the side yard. Mrs. Green was pregnant during the siege and gave birth to a son in one of the caves. She named him William Siege Green. Following Vicksburg's surrender to the Union forces on July 4, 1863, the mansion was leased to the U.S. government as a Soldiers' Home. The Greens moved back into their home in 1866 and remained there until Duff Green's death in 1880. That same year, Mary Green sold the house to the Peatross family. Members of the Peatross family lived in the house until 1910, when it was purchased as a temporary residence for Fannie Vick Johnston, who lived there until her new home, Oak Hill, was completed in 1913. After Fannie Vick Johnston moved into Oak Hill, known today as Stained-Glass Manor, Ms. Johnston allowed the Duff Green Mansion to be used as a boys' orphanage and, later on, a home for elderly, destitute women. When Fannie Vick Johnston died in 1931, her heirs sold the house for $3,000 to the Salvation Army, which stayed there for over fifty years.

In 1984, Mr. and Mrs. Harry Carter Sharp bought the old house with the intention of converting it into a bed-and-breakfast. For the next two and a half years, the Sharps embarked on an extensive remodeling project. Under the direction of local architect Skip Tuminello, the U.S. Department of the Interior and the Mississippi Department of Archives and History, the Duff Green

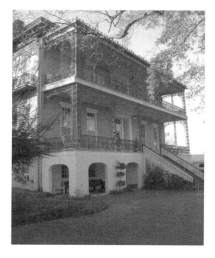

Left: Duff Green Manor.

Below: The hillside in the yard of the Duff Green Manor where the Green family dug caves to escape the bombardment.

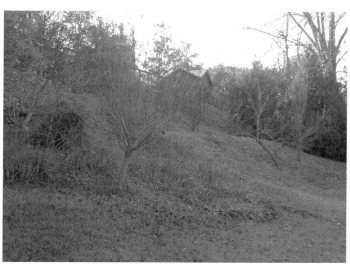

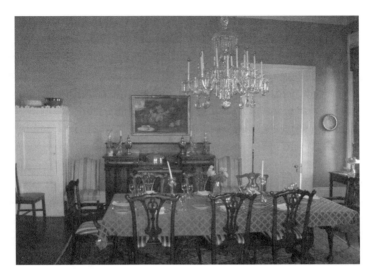

The dining room at Duff Green Manor.

Mansion was restored to its antebellum glory. Today, the Duff Green Mansion is hailed by architects as one of the finest examples of Palladian architecture in Mississippi. The old house is of intense interest to paranormal researchers because of its ghosts.

Two of the ghosts in the Duff Green Mansion are the spirits of women. In an interview with the *Vicksburg Post*, owner Henry Sharp said, "I've seen the ghost of Mary Green floating in the entrance of that doorway, plain as day." Breakfast cook Catherine Miller, who has seen Mary's ghost ten times, described her as a beautiful woman with blond hair.

In an interview with WJTV, Miller described an encounter she had with Mary's ghost one morning while making breakfast: "I was standing there over the stove stirring my grits, and I felt this rubbing on my shoulders. I thought someone had walked in behind me—teasing me or something like that. But I looked back, and there wasn't anyone there. Then I knew it was Mrs. Green." Several people have described Mary's ghost as wearing a green antebellum dress.

The ghost of Mary Green's daughter, who died young, has been seen playing with a ball or running up and down the staircase. She is described as a little blond girl in a white nightgown. Sometimes, only her disembodied footsteps are heard on the stairs. David Sharp says that he has heard the child's footsteps several times.

The Duff Green Mansion's best-known ghost is probably the spirit of a Confederate soldier who was operated on in the old house during the Siege of Vicksburg. According to local historians, amputations were performed in one of the basement rooms that had windows above ground. The limbs the surgeons had removed during surgery were thrown out of the basement window. The story goes that by the end of the busiest days, so many amputations had been performed in the basement that the pile of arms and legs was over five feet high. When the mansion was remodeled in the mid-1980s, workmen excavating around the foundation of the house discovered several human bones that bore the marks of a surgical saw. The manager called the police, who transported the bones to a local funeral home for interment.

The room where hundreds of soldiers had their arms and legs cut off is the Dixie Room. Many people have woken up in the middle of the night and seen a man dressed in a Confederate uniform. The man is usually rocking in a rocking chair or standing by a mantle. All of the witnesses say that man has only one leg and that he stares straight ahead. Over fifty people claim to have seen the one-legged soldier. None of these witnesses realized that the room was haunted before the ghost appeared. Doctors and nurses have detected medical smells in the Dixie Room, especially the smell of gangrene. In May 2005, a woman and her teenage daughter smelled a very bad odor during their second night in the Dixie Room. In 2002, an employee, Brian Riley, was walking down the hallway late one afternoon. When he looked into the Dixie Room, Riley noticed that all of the lights were on. He turned off the lights and left the room. This happened two or three times that day.

A few people have captured photographic evidence of the hauntings in the Duff Green Mansion. In the early 2000s, a crime scene investigator from Louisiana was taking pictures one afternoon on the grounds of the Duff Green Mansion. In one of the photographs, one can clearly see the image of a black humanlike figure standing on the steps. After looking at the photograph, David Sharp was deeply disturbed. "That really shook me up because I knew the place was haunted, but I never wanted to see a ghost, and I saw that on camera and didn't really want to stay here anymore." In 2002, a group of investigators took over

seventy photographs at Duff Green Mansion, but none of the photographs was accessible.

Paranormal activity occurs so often at the Duff Green Mansion that no one who works there really feels threatened. David Sharp said, "I've heard many unexplained sounds, and hardly a week goes by that I don't see something unnatural move out of the corner of my eye." Employee Brian Riley said that the paranormal activity happens twenty-four hours a day. "You just never know when it's going to happen," he added. Civil War soldiers seem to be the most common apparitions at the Duff Green Mansion, but guests have also seen a pair of undertakers and angels. Workmen noticed a strange white light darting around the attic. Interestingly, though, few people seem to be frightened inside the house. In fact, David Sharp recalled only two guests who were too scared to spend the night at the Duff Green Mansion. Lib Galloway, who worked at the mansion, viewed the ghosts as comfortable presences. "I felt like the house was sheltering me, protecting me and taking care of me," Galloway said.

The Duff Green Mansion has all the amenities that guests accustomed to being pampered are looking for. Each of the five guest rooms has a private bath and a working fireplace. The swimming pool is surrounded by a patio where guests can sunbathe. The old home's nineteenth-century charm has made it a favorite venue for bridal showers, weddings, rehearsal dinners and other functions. Apparently, the building's haunted history has not really diminished the bed-and-breakfast's appeal.

MCRAVEN

McRaven, at 1445 Harrison Street, is the most famous—
and historic—antebellum home in Vicksburg. It was
built in three stages. Andrew Glass built the first part—the
back section of the house—in 1797 in Walnut Hills, a small
town that has been incorporated into present-day Vicksburg.
McRaven derives its name from the original name of the
street on which it is located, McRaven Street. Glass and
his brothers were reputed to have been highwaymen in the
late eighteenth and early nineteenth centuries. When Glass
lived here, the structure was nothing more than one room
built on top of another room. Sheriff Stephen Howard
built the second part of McRaven—the front section—in
the Empire style in 1836. Howard added the downstairs
dining room and the bedroom up above. He also enclosed
the porches of the first part of the house.

In 1849, John H. Bobb completed the final addition to the
house in the Greek Revival style. This section includes the

upstairs gentlemen's dressing room and master bedroom, the parlor hallway and a flying wing staircase. In 1882, Mrs. Bobb sold McRaven to William Murray, a Union soldier who had married a girl from Vicksburg in 1865 while he was working as a blacksmith for the occupying army. The Murrays had seven children. Two of his daughters, Annie and Ella, were the last members of the Murray family to live in McRaven. The spinster sisters never installed indoor plumbing or electricity. They cooked in the kitchen in the front section of the house. People say that when the sisters became very old, they burned some of the furniture to keep the house warm. Their refusal to furnish their house with twentieth-century amenities preserved the old house's authentic nineteenth-century features.

In 1960, current owner Leyland French acquired McRaven after the last of the Murray sisters, Ella, died in the dining room. French converted it into a tour home. Today, the antebellum home is widely known as the most haunted house, not just in Vicksburg, but in the entire state.

The first violent death associated with McRaven involved John H. Bobb. In 1864, John H. Bobb and his nephew, Austin D. Mattingly, were walking up the road to the house when they noticed a group of Federal soldiers picking flowers from Bobb's garden. Bobb approached a burly sergeant and ordered him and his men off his property. The sergeant refused, and a fight ensued between the two men. Bobb picked up a brick and struck the sergeant in the head. As the soldiers dragged the bloodied

sergeant away, one of them swore that they would return one night and burn the house down. The next day, Bobb arrived at the headquarters of General Henry W. Slocum, the Union commander of the troops occupying Vicksburg, and complained about the behavior of his soldiers. Slocum promised that he would order his men to leave Bobb and his house alone. As Bobb and Mattingly were walking down the drive to McRaven, they were accosted by a small group of Union soldiers. They led the two men down Stout's Bayou and stopped behind the railroad machine shop. The soldiers shot Bobb twice and killed him. In the confusion, Mattingly managed to escape.

The first reported sighting in McRaven was recorded in the *Vicksburg Daily Herald* in July 1864. At midnight, a Yankee officer who was staying at McRaven as part of the Union army's occupying forces was awakened from a sound sleep by a rustling sound. When his eyes were finally able to focus, the officer saw the apparition of a turncoat Confederate soldier who had served the Yankee officer on board a steamer during the Siege of Vicksburg. The ghost had entered the room without opening a door or window. In the few seconds before the specter disappeared completely, the officer noticed that the figure was tall and gaunt and that his face was mutilated near one of his eyes. He appeared to be wearing white clothing. The officer demanded that the apparition identify himself. The ghost did, indeed, give his name, and then he vanished. The article went on to say that the ghost appeared in the house several times thereafter,

usually at night. People living in the house also reported hearing strange knocking sounds early in the morning.

McRaven is one of those rare houses that is said to be haunted on the outside as well as on the inside. People who had never been inside McRaven said that they saw ghosts of Civil War soldiers wandering around the grounds. Sightings such as these lent validity to the rumors that some of the wounded soldiers who were treated at McRaven in 1863 were buried behind the house. A number of Civil War reenactors camping on the property claim that a soldier dressed in a dirty, ragged blue Civil War uniform sat down at their camp fire late at night, drank a cup of coffee and disappeared.

Ever since the tours first started, tour guides began talking about the unexplained occurrences at McRaven. In 1984, a tour guide was leading a small group through the house when a woman asked if the piano still worked. The tour guide pressed down on one of the keys, and when no sound was produced, she said, "I don't think so." The group left the room, and a few seconds later they heard a few bars of a waltz being played on the piano.

In 1985, French had his own ghostly encounter inside the house. He said he was walking up the great flying-wing staircase when he turned around and saw a man on the landing. French recognized the man as William Murray from photographs he had seen of the man. Terrified, French dashed up the stairs and locked himself in the Bobb bedroom. For several minutes, he stood directly behind

the door and stared at the doorknob. After French finally calmed down, he contacted the local Episcopal priest and asked him to bless the house.

French never saw the specter of William Murray again. However, he did have an even more horrifying experience a few weeks later. French was polishing furniture in preparation for the tourist season when the telephone rang. He started walking across the room to answer the phone when he felt a hand on his back behind his shoulder blades. Then something shoved him down to the floor with such force that his glasses were pushed into his face. After regaining his composure, French drove to Parkview Hospital, where he received five stitches.

After French's violent confrontation with one of the entities inside McRaven, the house took on a very negative feeling, which French, the tour guides and the tourists themselves began to sense. French finally decided that something had to be done one evening when he was in his bedroom. He put his thumbs on the outer lip of one of the dresser drawers and had just pulled it out when he heard a noise on the stairs. All at once, the drawer slammed shut and smashed his thumbs. After dressing his wounds, French contacted an Episcopal priest and asked him to bless the house.

In 1986, local history professor Charles Sullivan was given the opportunity to determine for himself the validity of the stories he had heard about McRaven. Sullivan had developed an abiding interest in the old house ever since he had read the first published account of an encounter

with a ghost in the July 1864 edition of the *Vicksburg Daily Herald*. Sullivan's dream of spending the night in McRaven came true as the result of favorable comments he had made in a newspaper article in August 1986 regarding Leland French's efforts to preserve and maintain McRaven. A few days after the article was published, Sullivan received a phone call from French inviting him to the house. The history professor was elated. Sullivan recounted his fateful night at McRaven in an article published in the September/ October 1989 edition of *Mississippi* magazine.

Sullivan arrived at McRaven on the afternoon of December 20, 1986. He and French talked until long after sunset. When bedtime came, French escorted Sullivan to the middle bedroom. French told Sullivan that the chandeliers were activated with pressure switches underneath the flying-wing staircase. French neglected to tell Sullivan that the chandeliers had a tendency to come on by themselves. He led Sullivan up the front stairs, past the front bedroom and to the middle bedroom across the hall. After French said good night, Sullivan turned off the lights and fell asleep. At 3:00 a.m., he sat straight up in bed just as the grandfather clock tolled three times. All of the electric candles on the chandelier were ablaze. The lamp by the bed was turned on as well. Sullivan convinced himself that French had accidentally touched the buttons on the master switch downstairs, and he went back to sleep.

The next morning, Sullivan met French down in the bunker for coffee. He then spent the rest of the morning

calling several Civil War reenactors he knew to invite them to discuss living history demonstrations at McRaven with French. Some of the reenactors spent the afternoon looking for shell fragments, bullets and buttons on the property with their metal detectors. After the sun went down, Sullivan returned to the middle bedroom to dress for dinner. He was tying his tie when he heard footsteps outside on the veranda. Curious about why anyone would be pacing on the veranda on such a cold, windy night, Sullivan called the name of some of his friends, but no one answered. He peered through the window but could see nothing in darkness. Scratching his head, Sullivan turned off the lights in the room and went downstairs. When he told French about hearing the footsteps outside his bedroom, French replied that it was probably William Murray. "He likes to pace the gallery, smoke his pipe and look at the city," French said. The other guests found humor in French's statement. They knew that William Murray had been dead for seventy-five years. The guests then drove into town to celebrate New Year's Eve at one of the city's restaurants.

The group returned to McRaven about 1:00 a.m. Sullivan retired to the middle bedroom at 1:30 a.m. He was surprised that all of the lights were turned on. The next morning, Sullivan thanked French for turning on the lights while he was gone. French said that he had not even been up to the middle bedroom.

Sullivan did not spend another night at McRaven until June 4, 1987. He had come to return artifacts belonging to

one of the home's former owners, Sara Dogan Dickson, to McRaven. Sullivan had discovered the artifacts in Charleston, Mississippi. He arrived at McRaven at 9:00 p.m. Sullivan arranged the artifacts on the dining room table while waiting for French to come up from the bunker. While Sullivan was standing there all by himself, he became very cold. He sensed that a presence was in the room with him. When he told French about his uneasy feelings at the table, French merely replied, "Well, you know, the house has a way of getting back its own." Sullivan was so tired from his long journey that he was completely oblivious to any ghostly incidents that might have occurred while he was asleep in the middle bedroom.

Sullivan spent another night in the middle bedroom on June 5, the eve of his wedding in the parlor of McRaven. He had just fallen asleep when he was awakened by the bong of the grandfather clock downstairs. The bedside lamp came on by itself at 3:00 a.m., just as it had the last time he slept in the room, six months earlier. The chandelier lights were not on. He knew that French was able to turn on the chandelier downstairs but not the bedside lamp. Sullivan's fear of whatever had turned on the lamp kept him awake all night. At first dawn, he ran down the stairs and pounded on French's bedroom door. Sullivan informed French that he would not return to the middle bedroom to get his clothes. He also said that he would never spend another night in McRaven.

After Sullivan and his wife, Jane, were married in the parlor, they went to Memphis for their honeymoon.

When they returned to McRaven four days later, the groundskeeper, R.D. Forbes, loaded Jane's car with wedding gifts. She then drove off to Perkinson while Sullivan stayed behind to do research in the Warren County Courthouse. After her car had driven out of sight, Forbes told Sullivan about a strange experience he had had at dusk the night after the wedding. He said that on June 7, 1987, after the tour guides left at 6:00 p.m., Forbes and French had walked down Harrison Street to see a friend. When they returned at sundown, Forbes parked his truck on the gravel lot and looked over at the window in the middle bedroom. The first thing he noticed was that the lights were on. He could then make out the form of a woman standing against the glass doors leading from the hall between the two bedrooms. She was wearing a brown dress with a flower-pattern design. He could see her hair but not her face. Forbes continued watching the woman for five minutes. Suddenly, he realized that French would want to see the apparition too. Forbes turned around and yelled for French. When Forbes looked back at the woman, she was slowly fading away. After Forbes met up with French, the two of them searched the house for an intruder, but no one was found.

The answer to the question of why McRaven is so haunted might have been supplied by parapsychologists William Roll and Andrew Nichols. The two men investigated McRaven in 1999 on Memorial Day weekend, when a reenactment of the Siege of Vicksburg was being staged. The parapsychologists believed that because of

the timing of their visit, McRaven's ghosts would be most active. Using their instruments, Roll and Nichols discovered that McRaven had been built atop an electric field, which turned the old house into a sort of storage battery. Nichols said that the energies within the house also enhanced the inhabitants' ability to perceive paranormal activity. Roll and Nichols concluded that the high number of paranormal incidents at McRaven was due primarily to the electric field on which it sat.

THE LUCKETT GROUP

The Luckett Group is a name given to four antebellum cottages at the end of Crawford Street. All of these houses were built in the 1830s. In 1977, Jim Gorney and his wife, Debbie, rented the upper floor of one of these little cottages. "There used to be stables beneath us," Jim said. "The cottage was made of Vicksburg brick. It was built as one story on a hill, and as they expanded the house, they cut the hill out and put brick underneath it to make a two-story house." Because Jim and Debbie were trying to live on teachers' salaries, the inexpensive little apartment suited their needs perfectly.

Jim soon discovered that their apartment was more special than he realized:

> *One night, I was messing around in the fireplace in the living room. I had cleaned the firebrick up, and I was taking out the gas hookups. In the 1920s and 1930s,*

they used gas. Prior to that, they had converted to a coal burner. So I was cleaning up the brick, washing it off. It was dark that night—the lighting was very poor. Suddenly, I saw something dark in the room. It looked like a human being. It was there a few seconds, and then it was gone.

At first, Jim thought that he had seen a ghost. In recent years, however, he has attributed his sighting to his upbringing:

My people are German from Iowa on the river, around Guttenburg, Iowa. My grandmother was all German. I was brought up hearing about poltergeists, and I don't know if I have a vivid imagination that way or if you can really trust me. I used to sit and listen to my grandma when I was a child in the 1950s. She talked a lot about her little house in Iowa on the Turkey River. She always claimed things flew out of cabinets. That might have been the beginning of my "conjuring up" things.

The fact that Jim Gorney had another sighting at the Nurses' Station might also suggest that he is one of those sensitive people who seem to have an affinity for ghosts.

THE NURSES' STATION

The Duff Green House at 1113 First East Street served as an important field hospital during the Siege of Vicksburg. Hundreds of lives were saved by the surgeons who toiled there for weeks. However, the innocuous-looking building right across the street was equally important. The nurses who assisted the surgeons stayed across the street at 1115 First East Street. The Nurses' Station, which was built in 1830, is now listed on the National Register of Historic Places. To one resident in Vicksburg, the old house seems to hold more than just the memories of the most tragic period in Vicksburg's history.

In 1976, Vicksburg residents Jim Gorney and his wife, Debbie, had just gotten married. While they were looking for a place to live in Vicksburg, they became interested in the old house at 1115 East Street. "An architect in Vicksburg, Skippy Tuminello, had it for sale, so we took out a binder on the house," Jim said.

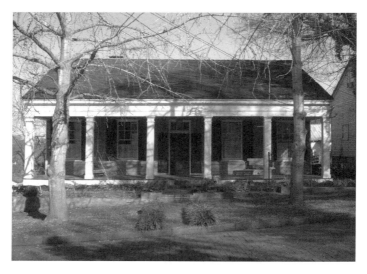

The Nurses' Station.

While we had that binder on the house, I began to excavate. It had a partial basement—a crawl space—made out of the old Vicksburg brick. It was damp, musty, smelly. I was young—I was in my twenties—so I got a wheelbarrow and a shovel from my father-in-law, who lives up the river on Washington Street in old Victoria. I went in the basement one day late in the summer. The basement was OK to work in because it was cool and damp.

Jim had been working for an hour or so and had removed a couple of wheelbarrows full of dirt. He dumped his second load and returned to the basement. "I was going to dig down and expose more of the brick and then clean it up down there," Jim said.

> *Suddenly, I saw what I thought to be the face of a man on the far wall. I couldn't see it very well. The place had poor lighting. I had one of those trouble lights and an extension cord, and it was dangling at the back. The face was there, and then it was gone in just a few seconds. Man, I busted out of there. I didn't go back in. It shook me up that much.*

Jim Gorney's terrifying experience in the basement of the Nurses' Station is still etched in his memory. These days, though, he is able to look back on the incident more objectively:

> *Afterward, I came to realize that it might not be anything, that my mind was playing tricks. But I did tell Debbie, and for years, we had a good laugh about it. But I'll tell you what I didn't do. I didn't go back in that crawl space with that wheelbarrow and that shovel. A few months after that, we decided we would give up the binder money that we put down on it and try something else. My father was a stonemason, so we built a home out in the country here.*

The reason Jim gives for not buying the Nurses' Station is the fact that it had termites and other structural problems. One wonders, though, if the apparition he encountered in the basement did not also figure into his decision.

THE OLD COURTHOUSE MUSEUM

The Old Courthouse Museum is Vicksburg's most historic structure. In 1858, the contractors, the Weldon Brothers of Rodney, Mississippi, began constructing the courthouse on a high hill donated by the family of the founder of Vicksburg, Newitt Vick. About one hundred slaves made the bricks and erected the building. After the magnificent structure was completed in 1860 at a cost of $100,000, it was hailed by the American Institute of Architects as one of the twenty most outstanding courthouses in America. The building is adorned with thirty-foot Ionic entrance columns, iron shutters and doors and an iron stairway connecting the first and second floors.

The Old Courthouse played a prominent role in Vicksburg's most historic moments. Jefferson Davis's political career got its start at the courthouse. During the Siege and Battle of Vicksburg, the Union artillery targeted the city by focusing its sights on the clock tower atop the

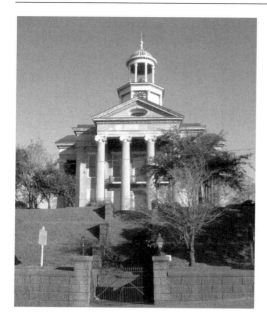

The Old
Courthouse
Museum.

courthouse. In fact, a Union mortar shell struck the cupola in 1863, killing two Confederate soldiers who were using it as a signaling station. This was the only major hit that the courthouse sustained during the entire Civil War. The story goes that three Confederate generals—John C. Breckinridge, Stephen D. Lee and Earl Van Dorn—watched the Confederate ironclad *Arkansas* fight its way through the Union blockade of the Mississippi right outside Vicksburg. At the end of the siege on July 4, 1863, General Grant and Lieutenant General John Pemberton rode their horses to

the courthouse from Pemberton's headquarters to watch the lowering of the Stars and Bars and the raising of the American flag at the courthouse. After the Civil War, the U.S. Army used the old courtroom.

The historical significance of the Old Courthouse can be measured by the number of dignitaries who walked up its steps. Booker T. Washington, President Zachary Taylor, President William McKinley and President Theodore Roosevelt all gave speeches at the courthouse. Between 1859 and 1939, a number of important cases were tried in the upstairs courtroom in an effort to regain possession for Davis of Brierfield Plantation, which was confiscated after the Civil War. Davis lost his case, primarily because carpetbaggers dominated the court proceedings, but he regained possession of the plantation later on when he appealed his case to the Mississippi Supreme Court.

Ironically, the Old Courthouse faced an even more serious threat after the Civil War. After the construction of the new Warren County Courthouse in 1939, the Old Courthouse was abandoned. Some city officials began talking about razing the vacant building. The beautiful old building was saved from the wrecking ball in 1947, when Eva Whitaker Davis, president of the Warren County Historical Society, mobilized volunteers and started cleaning and restoring the courthouse. They also began collecting artifacts from the Civil War and other historical periods, including antique furniture,

period portraits, fine china, nineteenth-century toys, muskets, battle flags, bayonets, artillery shells and tools used by Indians and pioneers. On June 3, 1948, the Old Courthouse Museum opened its doors. It was declared a National Historic Landmark in 1968. Today, the Old Courthouse Museum is run by the Vicksburg and Warren County Historical Society.

The staff at the Old Courthouse discounts the presence of ghosts in the old building. However, over the years, locals have talked about the ghosts in the courtroom. For eighty years, hundreds of prisoners were tried here, many on the charge of murder. One of the highest-profile cases involved the murder of a white Union officer by a black Confederate officer named Holt Collier. A volunteer who worked in the gift shop for many years said that, on more than one occasion, she was in the courtroom on the second floor when she heard what sounded like chains being dragged across the floor in the back room. Prisoners awaiting trial were held in this room directly behind the judge's bench. She also said that sometimes when she was working on the first floor, she heard footsteps up in the courtrooms. When she walked upstairs to see who was there, the courtroom was always empty.

Another part of the courthouse that is said to be haunted is the bell tower. People passing by the courthouse have seen a shadowy figure walking around the bell tower. However, there could be a rational explanation for what people have seen. A door that sometimes flops open on

The Old Courthouse Museum

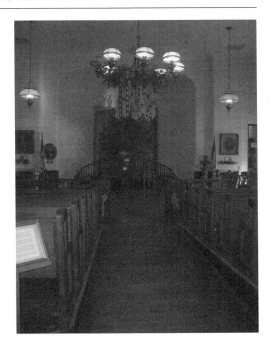

The courtroom of the Old Courthouse Museum.

windy nights could be mistaken for human movement on the bell tower.

The exhibits in the Old Courthouse Museum include a wide variety of historically significant artifacts. These priceless treasures include an original teddy bear given to a child in Vicksburg by President Theodore Roosevelt, Jefferson Davis's tie, an executive chair used by General Grant during the occupation of Vicksburg, trophy antlers won by the steamboat *Robert E. Lee* in a race in 1870, the original captain's wheel from a huge stern-

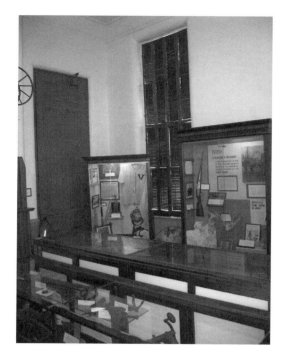

A display case at the Old Courthouse Museum.

wheeler named the *Sprague* and a Confederate flag that never surrendered. Sadly, the names of many of the men and women who were tried and sentenced in the Old Courthouse have been lost to history. Perhaps this is the reason their spirits are trying to make their presence known in the courtroom.

PEMBERTON'S HEADQUARTERS

General John Clifford Pemberton was born on August 10, 1814, in Philadelphia, Pennsylvania. After graduating from West Point in 1837, Pemberton fought in the Second Seminole War and in the Mexican War. Pemberton resigned from the U.S. Army in 1861 and moved to his wife's home state of Virginia. He enlisted in the Confederate army and was promoted to major general in 1862. After commanding the Department of South Carolina and Georgia, Pemberton was promoted to lieutenant general and given the task of overseeing the defense of Vicksburg. Many citizens of Vicksburg were skeptical that a native of Pennsylvania could adequately defend Vicksburg, but Pemberton quickly proved the naysayers wrong by solving the Confederate army's problems with morale and supplies. He successfully repelled General Grant's army in 1862 but was finally forced to capitulate on July 4, 1863, after sustaining a devastating siege of forty-seven days.

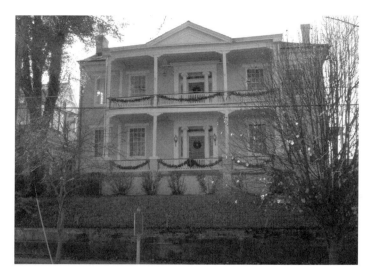

Pemberton's Headquarters.

Pemberton's rank was reduced to lieutenant colonel, by his own request, and he was placed in charge of artillery in Virginia and South Carolina. Pemberton died in Penllyn, Pennsylvania, on July 13, 1881.

The house where Pemberton lived from May 23 to July 4, 1863, was originally built by William Bobb in 1835–36 in the Greek Revival style. At the time Pemberton appropriated the house, it was owned by John Willis, a descendant of the founder of Vicksburg, Reverend Newitt Vick. The house is located at 1918 Crawford Street in a neighborhood of what were then some of the most handsome houses in

Vicksburg. In 1890, Mary Frances Cowan purchased the house. Between 1895 and 1899, Confederate and Union veterans petitioned unsuccessfully for the inclusion of the house in the legislation designating the battlefield as a National Historic Site. The Cowan family continued living in the house until 1914. In 1919, Mrs. Cowan's heirs sold the property to the Sisters of Mercy. The religious order renamed the house St. Anthony's Hall and used it for dormitories, as a nursing school and as St. Francis Xavier Kindergarten. The old house was listed on the National Registry of Historic Places in 1970. In 1973, the Sisters of Mercy sold the house, and it once again became a private residence. Over the next twenty years, the house was open for tours. It was also a bed-and-breakfast for a short while. Then, in 2003, the National Park Service acquired the house, which by then was known as the Awillis-Cowan House. In May 2008, the house was again opened for tours.

The only hauntings reported at Pemberton's Headquarters have been on the lawn behind the house. In the mid-2000s, employees at the Baldwin House next door looked out the front window and saw a group of Confederate soldiers walking around the front yard. Assuming that the soldiers were reenactors who had stopped by the Baldwin House for lunch, the employees notified the rest of the staff, who set about setting the tables. When one of the employees looked out the window again, she saw the soldiers march to the back of Pemberton's Headquarters and then disappear. People familiar with the history of Crawford Street believe

that these are the ghosts of Confederate soldiers who bivouacked behind the old house back when General Pemberton stayed there.

At the time of this printing, plans were being made to restore the interior and exterior of Pemberton's Headquarters. The National Park Service is also going to preserve the exterior of the 1919 addition to the rear of the house. The increased number of people working outside of Pemberton's Headquarters will undoubtedly lead to even more sightings of the phantom soldiers.

SERGEANT SMITH PRENTISS BUILDING

Sergeant Smith Prentiss gained fame as a representative from Mississippi to the United States Congress. He was born in Portland, Maine, on September 30, 1808. He was struck by an almost fatal illness that paralyzed and withered one of his limbs. Because he could not play outside with the other children, Prentiss stayed inside and read books like the Bible and Bunyan's *Pilgrim's Progress*. He entered Gorham Academy at the age of twelve. Three years later, he entered Bowdoin College. After graduating in 1827, he began the study of law in the office of Josiah Pierce. However, because most lawyers in New England spent their first year in practice in poverty, Prentiss decided to go to the new state of Mississippi, where there were opportunities for ambitious young men.

Prentiss started out as a tutor in the home of William B. Shields, the former attorney general of the Mississippi Territory who died in 1823. In 1829, Prentiss entered the

Sergeant S. Prentiss Building.

law office of Robert J. Walker. He was admitted to the bar in Monticello, Mississippi, that year. He then moved to Natchez, where he became the law partner of General Felix Houston. In January 1832, Prentiss relocated to Vicksburg and became the law partner of John L. Guion. In August 1834, Prentiss delivered an oration at the state capitol in honor of General Lafayette. Prentiss soon became one of the most popular orators in the country. He served in the state House of Representatives in 1836–37. He filled the vacancy left by John F.H. Claiborne in the U.S. House from May 30, 1838, to March 3, 1839. After a failed bid

for election to the United States Senate in 1840, Prentiss returned to Vicksburg. In 1845, Prentiss moved to New Orleans and began practicing law there. In June 1850, he collapsed in the courtroom while trying a case. He was taken to Natchez, and he died in Longwood on July 1, 1850.

Today, the little building located behind the Old Courthouse Museum at 1010 Monroe Street is the office of architect Skip Tuminello, who restored it and many other historic buildings in Vicksburg. The office was built in 1791, and in 1830, it served as the law office of Jefferson Davis. Sergeant Prentiss took over the office in 1840 and remained here for the next five years. After the Civil War, the Portee family from Louisiana moved into the house. Mr. Tuminello said that an elderly member of the Portee family was sitting on the front porch knitting one day while a group of neighborhood boys were playing baseball. A hard-hit ball struck the lady in the head and killed her.

When Mr. Tuminello moved into the old building, he was surprised to find that it was constructed of bricks that had been cut—not formed in molds—which was the customary way of making bricks in the nineteenth century. He said that when the chimney was restored, Civil War–era bricks were used. Mr. Tuminello also said that the building is an oddity because it is a combination of the Federal, Italianate and Greek Revival styles.

The Sergeant Smith Prentiss building is also unusual because it is reputed to be haunted. For years, people talked about the ghost of the white-haired lady in a long,

flowing gown that occasionally appeared in the upper porch. When my wife, Marilyn, and I visited Vicksburg on December 18, 2009, we took pictures of the old building at about 8:30 p.m. in the hope of catching a picture of the elderly spirit. Unfortunately, ghosts do not perform on cue, so we did not capture any full-bodied apparitions with our digital cameras. However, I did catch an orb in one of my photographs. It was hovering around the middle of the upper front porch. I found out later that a number of people have gotten orbs in their photographs at this location. Some experts in the paranormal would say that the restoration process awakened the old woman's spirit, which is reluctant to leave her front porch.

STAINED-GLASS MANOR

Fannie Vick Willis Johnson, the builder of Stained-Glass Manor, was a direct descendant of Burwell Vick, the founder of Vicksburg. She was born on December 3, 1853, to John and Annie Ricks. While attending St. Francis Xavier School, Fannie and her family lived at 2430 Crawford Street. Her family home became the headquarters of General Pemberton during the Siege of Vicksburg. On May 3, 1881, she married Junius Ward Pemberton. Between 1881 and 1908, Fannie and Julius lived between the Willis-Cowan House, Duff Green Mansion and Panther Burn Plantation. In 1902, Fannie and Junius hired George Washington Maher to build their dream home, Oak Hall, at 2430 Drummond Street in Vicksburg.

Maher was Frank Lloyd Wright's instructor, and many of Oak Hall's architectural elements can also be found in many of the buildings Wright designed. The house's most distinctive features are the thirty-eight original stained-glass

Stained-Glass Manor.

windows. The windows were created by Louis J. Millet, the first dean of architecture in Chicago and head of the Art Institute. Several of the designs are clearly the work of one of dean's subcontractors, Louis Comfort Tiffany. LaMantia of New Orleans crated the contemporary patterns. The mansion was completed in 1908.

Fannie and Junius shared the happiest time of their lives at Oak Hall. In 1919, Fannie's life changed forever. Junius was killed when a tornado struck Panther Burns. She sold the plantation the same year. Fannie devoted the rest of her life to philanthropy. In 1929, the Rotary

Club recognized her charity work by awarding her the Loving Cup Award. In 1931, Fannie Vick Willis Johnson passed away. The inscription on her tombstone—"She lived for others"—commemorated her selfless devotion to the people of Vicksburg. For the next thirty-five years, Oak Hall served as a widows' home, operated by the Episcopal Diocese. In 1966, Mayor Johan Holland and his wife, Sarah, bought the old house and converted it once more into a private residence. Over the next few years, a series of renters and owners inhabited Oak Hall. Then, in 1995, Bill and Shirley Smollen became the trustees of the nonprofit Stained-Glass Manor/Oak Hall Historic Association. Today, Shirley Smollen operates Stained-Glass Manor as a bed-and-breakfast. When the Smollens opened Stained-Glass Manor, they knew that the old house was rich in history, but they did not dream that some of that history was still roaming the halls.

In an interview with author Sheila Turnage, Bill Smollen, a retired systems engineer for NASA, said that the bed-and-breakfast had not been open for long before he and Shirley began receiving complaints from guests about the "noisy ghosts" that were keeping them awake all night. Bill began taking these reports seriously when items like tape measures and cameras were mysteriously moved from one location to another. The disturbances finally became so frequent that the Smollens had the house exorcised in 1996 or 1997.

Bill Smollen said that after the exorcism, the paranormal activity in Stained-Glass Manor died down considerably.

The only really active spirit inside the house now is the ghost of Fannie Vick. Fannie's apparition has been seen in the front yard, but her ghost usually appears in the Fannie Vick Room. Her ghost has been seen ten or eleven times in her room since the bed-and-breakfast opened. Bill said that eyewitnesses have described her ghost as having long brown hair and wearing a white robe. Guests who are especially sensitive to the paranormal have found it difficult to stay in Fannie's room. Shirley Smollen told Sheila Turnage that grown men have walked into Fannie's room, turned around and walked right back out again. Without exception, all of

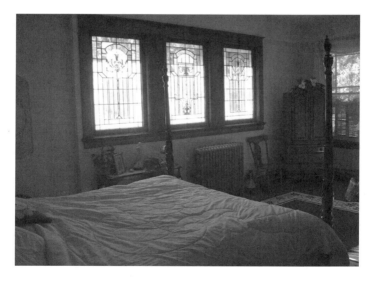

The Fannie Vick Room at Stained-Glass Manor.

these men had had near-death experiences at some point in their lives. Shirley added that a number of children who were touring the house also found it difficult to stay in the Fannie Vick Room. Because Fannie Vick's ghost is such a strong presence, a number of guests have captured orbs with their digital cameras in her room.

On another occasion, two elderly ladies who had come to Vicksburg to gamble in the casinos decided to spend a night at Stained-Glass Manor. Shirley Smollen said that later that evening, the two women returned to their room after a hard day's gambling. They were lying in bed when all of a sudden, the bed started shaking. Each lady accused the other of shaking the bed. The next day, the ladies told Shirley what had happened to them the night before. Shirley is convinced that Fannie Vick, who was a devout Christian, expressed her disapproval of the ladies' love of gambling by waking them up.

Although Fannie Vick's spirit has startled people in the past, her ghost has also been a comforting presence. Shirley Smollen said that one day in the late 1990s, a woman who was experiencing some severe personal problems booked the Fannie Vick Room for the night. Her health was bad, and she had financial problems. To make matters worse, her marriage was on the rocks. She was unpacking her suitcase when suddenly she felt herself enveloped in warmth. The woman told Shirley that it felt like someone was giving her a big hug. She got the impression that someone was trying to tell her that everything was going to be OK. Immediately,

the woman's depression was alleviated. Shirley believes that Fannie Vick's ghost sensed that the woman was suffering and tried to comfort her.

Apparently, Fannie does not restrict her movements to her bedroom. Shirley Smollen said that one night in the early 2000s, a retired colonel was staying in the room right next door to Fannie Vick's bedroom. The colonel said that he was lying in bed reading when the door to the room opened and a striking young woman walked in. She had long brown hair and was wearing a white dress. The colonel said that the woman took a few steps into the room, turned around and walked back out again. The colonel's description of the woman has convinced Shirley that he met the ghost of Fannie Vick.

Another haunted room in Stained-Glass Manor is the attic on the third floor. Bill Smollen told Sheila Turnage that in the late 1990s, a group of paranormal investigators was using a magnetometer to measure electromagnetic impulses in the room when, suddenly, the needle began spiking to absurd levels. The investigators interpreted the extreme fluctuations in the electromagnetic field as a sign that some traumatic event had occurred in the attic room sometime in the past. Before Shirley and Bill bought the house, they had heard that a boy had died in the attic room of heat stroke. However, after talking to an elderly resident of Vicksburg, Shirley believes that this residual energy was produced by a horrific murder that is rumored to have taken place in Stained-Glass Manor in the 1920s.

According to the story, a thirteen-year-old autistic boy was murdered in the attic room by two female occupants of the house. Shirley Smollen said that the women killed him because they feared that he would become sexually aggressive when he grew older. Some residents of Vicksburg believe that one of the women was Fannie Vick, who helped a friend kill the child because they feared that he would be unable to care for himself when he became an adult. In the early 2000s, an artist who was spending the night in the attic room fell asleep and dreamed that he was a thirteen-year-old boy. The artist said that in his dream, he was awakened when two ladies entered his room. They had hairstyles from the 1920s and wore white, high-necked blouses and long, dark skirts. One of the women grabbed a pillow and shoved it in his face. Both women put their weight on the pillow and smothered the boy. The artist had not heard about the alleged murder in the attic room before he had his dream.

Other guests have had strange experiences in the attic room. One evening, a woman who had brought her young son with her to Stained-Glass Manor asked the little boy if he would mind staying in the attic room by himself while she and her husband went out for the evening. The child said that he did not mind at all because there was a little boy up in the room who could play with him. On another occasion, a woman who was staying in the attic room came running down the stairs and almost knocked Shirley down. Shirley asked the woman what was wrong.

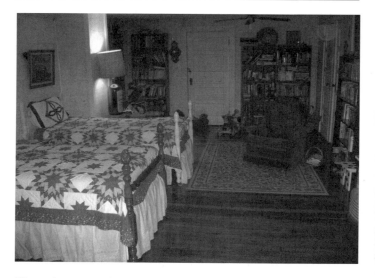

The attic room at Stained-Glass Manor where a little boy was allegedly murdered.

The woman said that she had returned to her room after lunch, and as soon as she walked in the door, she began feeling cold. Then she heard a man's voice coming from the bathroom. The woman said he seemed to be singing to himself while he was taking a bath. Shirley accompanied the woman back to the attic room, but no male intruders could be found.

Shirley feels a special bond to at least two of the spirits in her house. After her father died, she walked into her living room and was surprised to see the rocking chair rocking by itself. Not long after the death of her husband, Bill, she was

trying to type a letter to a judge on her electric typewriter and had difficulty getting the keys to work properly. Shirley's grandson, who had stopped by for a visit, sat down and started typing, and the typewriter worked perfectly. After her grandson left, Shirley told her husband's ghost to "stop playing around." She has not had any problems with the typewriter since then.

Occasionally, strange things happen that cannot be credited to a specific ghost. Lights flicker on and off, especially the light on the ceiling fan in the den on the second floor. Several times, something has set off the motion detector. No human trespassers have ever been found. Sometimes, when Shirley is in the house all by herself, she hears someone walking on the second floor. In the late 2000s, Shirley had just walked in the front door when she saw a woman wearing a large peony walk out of the dining room and up the staircase. Shirley followed the woman up the stairs but was unable to find her anywhere in the house.

When I stayed at Stained-Glass Manor in July 2009, Shirley pointed to an African American doll that was nestled in a pile of dolls sitting on the floor next to the side door. "Two years ago, that doll disappeared," Shirley said. "I looked for it everywhere and couldn't find it. Two years later, I was headed out the door, and I just happened to look at the dolls on the floor. There it was, back in its usual place. I don't know what happened to it."

Another incident involved a Bible belonging to a lady from Alabama who used to cook for the Smollens. "I don't

The doll collection at the side entrance of Stained-Glass Manor.

know why I have that lady's Bible," Shirley said. "But a prayer that was placed inside the Bible just knocked me out. It was a prayer that I needed at a particular moment."

One would think that living in a haunted house would be unnerving for a woman all by herself. However, Shirley has never felt threatened by any of the spirits in the house, especially the ghost of Fannie Vick. She agrees with her late husband, Bill, who described Fannie Vick as "very, very loving."

VICKSBURG NATIONAL MILITARY PARK

When Mississippi seceded from the Union on January 9, 1860, the value of the cities along the Mississippi doubled overnight. In 1863, Vicksburg was the last of the Mississippi port cities still under control of the Confederacy. Consequently, Vicksburg was crucial to the Southern cause. Fortifying Vicksburg became one of the prime objectives of the Confederacy. Taking Vicksburg was of equal importance to the Federal government because control of the Mississippi would ensure unhampered movement of Union soldiers. Once Vicksburg was in the hands of the Union, Arkansas—and most of Louisiana—would be cut off from the rest of the Confederacy. Abraham Lincoln, who was fully appraised of the strategic importance of Vicksburg, told his civilian and military leaders, "See what a lot of land these fellows hold, of which Vicksburg is the key! The war can never be brought to a close until that key is in our pocket."

A cannon demonstration at Vicksburg National Military Park.

Perched high on the bluffs, Vicksburg was known as the Gibraltar of the Confederacy. Confederate engineers transformed the city into a fortress after the fall of New Orleans in April 1862. By the spring of 1863, Vicksburg was protected by nine miles of fortifications positioned atop the hills surrounding the city. Nine forts mounting 172 guns guarded all approaches to Vicksburg, including the Third Louisiana Redan, known during the Siege as Fort Hill.

Admiral Farragut made the first attempt to take Vicksburg. His cruisers and gunboats bombarded the city from mid-May through July 1862. However, Farragut could not elevate his cannons high enough to strike Vicksburg on top of the bluffs. Union troops also tried to dig a canal across the hairpin turn at Vicksburg. Both efforts failed to weaken the city's defenses. The arrival of the Confederate ironclad *Arkansas* finally persuaded Farragut to retreat to Baton Rouge.

In October 1862, Major General Ulysses S. Grant was ordered to clear the Mississippi of all Confederate fortifications. His primary objective was, of course, the forced surrender of Vicksburg to Federal troops. His initial operations against Vicksburg began with a series of amphibious assaults, known as the Bayou Expeditions. Grant's attempt to attack Vicksburg head-on ended on December 29, 1862, with Major General William T. Sherman's defeat at the Battle of Chickasaw Bayou.

Federal attempts to take Vicksburg by water were equally unsuccessful. On December 12, 1862, the Union ironclad *Cairo*, under the command of Lieutenant Commander Thomas O. Selfridge Jr., and several other vessels sailed up the Yazoo. Their objective was to destroy Confederate battlements. Suddenly, two explosions erupted from the sides of the *Cairo*. The ironclad was the first vessel in history to be sunk by a mine. The *Cairo* remained on the muddy bottom of the Yazoo until 1964, when it was raised, restored and placed on display at the USS *Cairo* Museum adjacent to Vicksburg national Cemetery.

Grant's attempt to take Vicksburg by land resulted in nothing more than the decimation of Federal troops. He was under considerable pressure from above and below to force the surrender of Vicksburg as soon as possible. On October 20, 1862, General John McClernand received secret orders to raise a volunteer army to pummel the Confederate garrisons into submission. McClernand believed that his political aspirations would receive a

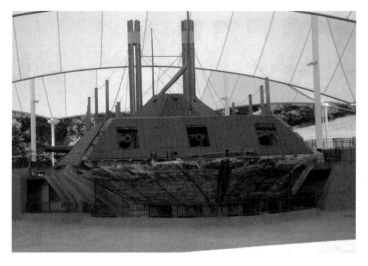

The bow of the ironclad *Cairo*.

considerable boost if his army captured Vicksburg. Grant learned of McClernand's army of unprofessional soldiers and hastened to finalize his own plan to take control of Vicksburg. He decided that the most prudent course of action would be to bypass the Confederate fortifications entirely. On March 29, 1863, he ordered his forty-five thousand troops to march down the Louisiana side of the Mississippi River. The plan was to cross the river south of the city and then attack the city from the south or east. A tip from a local resident prompted Grant to choose Bruinsburg, Mississippi, as his landing point.

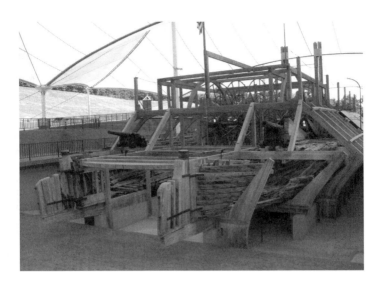

The ironclad *Cairo*.

After arriving in Bruinsburg on April 30, 1863, Grant's soldiers penetrated deeply into Mississippi. His troops defeated Confederate lieutenant general John C. Pemberton's forces near Port Gibson on May 1. On May 12, Grant's soldiers engaged the Confederates near Raymond and emerged victorious. Grant then turned his attention to Jackson, the capital of Mississippi. On May 14, Grant battled torrents of rain and muddy roads, as well as the Confederate defenses of the city. By the end of the day, Grant had taken control of Jackson with fewer than three hundred Federal casualties. Grant had prevented

Lieutenant General Joseph E. Johnston's Confederate forces from joining the Vicksburg defenders.

May 16 was one of the most crucial days of the campaign. Twenty-three thousand Confederate troops tried to halt the advance of Grant's army at Champion Hill, located halfway between Jackson and Vicksburg. After a bloody day of attack and counterattack, the Confederates were forced to retreat. Grant's troops also defeated the Confederate army the next day at the Big Black River, near Edwards.

On May 18, Grant's army gathered outside Vicksburg. His first attack on May 19 was repulsed. His forces made another attempt to take Vicksburg on May 22, over a three-mile front from Stockade Redan to Fort Garrott. Sherman, seeking to avoid the disastrous attack of May 19, asked for 150 volunteers to build a bridge across the Confederates' works. These 150 volunteers, who dubbed themselves the "Forlorn Hope," carried their portable bridge down the Graveyard Road. As the Forlorn Hope neared the Stockade Redan, it was cut down by withering fire. So many Union soldiers were killed in this assault that the Graveyard Road was clogged with the dead. Confederate private William Chambers observed that the ground in front of his lines was "blue with the dead."

An Irish regiment from Missouri was part of the second wave that attacked the Stockade Redan. Although the men managed to plant the regiment's green flag with the gold harp on top of the Great Redoubt, they, too, were forced to retreat. As the morning of May 23 broke, so much blood

had been spilled that the ground was soggy with it. Two thousand of Grant's soldiers lay dead or wounded along the Confederate lines. Because he was unwilling to sacrifice any more of his soldiers in what was to be a costly conflict, Grant decided to lay siege to Vicksburg.

Grant pounded away at the Confederate fortifications from the land. Ten Union divisions were placed along the entire seven miles of the Confederate front. Grant's artillery was arranged in a semicircle connecting the northern, eastern and southern flanks. Grant's soldiers also dug underground works that would protect them from Confederate sharpshooters and mask tunneling operations, or "mining approaches." After digging tunnels underneath the Confederate fortifications, the Federal soldiers planned to light explosives and blow them up. At the same time, Admiral David D. Porter's gunboats hammered away at Vicksburg from the river.

Meanwhile, hundreds of Union soldiers lay dead or dying on the battlefield. Pemberton sent a message to Grant stating that his men would bury the dead if Grant would call a truce, but Grant refused. However, when Federal troops began to complain about the vile odor wafting over from the battlefield, Grant relented. A truce was held between 6:00 p.m. and 8:00 p.m. on May 25. While they were burying the dead, soldiers from the North and the South mingled, exchanging letters to loved ones and food.

Civilians hunkered down in five hundred caves dug in the hillside for protection from the relentless shelling. It

turned out that over two-thirds of all the artillery fired from Grant's lines east of town landed in town. The caves were filthy and infested with snakes, but they were habitable. A few of the caves could hold more than one hundred people. The largest cave had an arched "great room" with smaller sleeping areas branching off of it. The shelling often continued all night long, feeding the citizens' terror of being buried alive. One young mother had just placed her child in bed when the concussion of a mortar shell caused tons of dirt to slide off the wall and smother him.

When the bombardment subsided, the citizens of Vicksburg resumed their normal lives. They subsisted on whatever was available. Most of the meals consumed by the civilians comprised mule meat, but apparently horses, dogs and even rats were consumed as well. They also lived on bread made from corn and dried peas. Miraculously, fewer than a dozen civilians were killed in the shelling, and only thirty were injured. Union soldiers occupied themselves by digging trenches toward Confederate lines. Confederate forces conducted raids against the Union army in a desperate attempt to lower the morale of the invaders from the North. The most sensational sortie was the burning of the Federal ironclad *Cincinnati* by Confederate raiders.

The soldiers on both sides were suffering as well. At any given time in the forty-seven-day siege, about five thousand of the thirty thousand soldiers in the Confederate army were in one of the field hospitals scattered across the city. Many of the wounded soldiers were treated in tents

and in private homes. By late June, however, half of the Confederate troops were on the sick list or in the hospital. Most of them were subsisting on one-quarter rations. The dead on both sides were wrapped in blankets and buried head to toe in fifty-foot-long trenches. Despite the fact that the soldiers and the citizens were living in deplorable conditions, their spirits were unbroken. In June, the editor of the *Vicksburg Daily Citizen*, which was being printed on the back of flowery wallpaper, responded to taunts by Union soldiers that Grant would be dining in Vicksburg with the following statement: "Ulysses must get into the city before he dines in it. The way to cook a rabbit is, 'first to catch the rabbit.'"

By July, Lieutenant General Pemberton knew that surrender was a foregone conclusion. He realized that no help was coming from General Joseph E. Johnston. Pemberton asked Generals Bowen and Smith to see if a breakout was feasible. Both generals said no. On July 3, General Pemberton and a cavalcade of horsemen brandishing white flags rode out from Vicksburg along the Jackson Road. General Pemberton rode beyond the works and met with General Grant under the shade of a stunted oak tree to discuss surrender terms. Grant demanded unconditional surrender, the same terms that had earned him his nickname. Pemberton refused, warning Grant that if he did not compromise, "You will bury many more of your men before you will enter Vicksburg." General Bowen, who had known Grant

before the war, helped Grant arrive at amended terms that would be acceptable to Pemberton.

At 10:00 p.m., Grant forwarded the amended terms to Pemberton. Under the new terms, Confederate soldiers would be granted parole. General Pemberton and his officers accepted the terms in his headquarters on Crawford Street. At 10:00 a.m. on July 4, the tattered defenders of Vicksburg stacked their arms, removed their accoutrements and furled their flags. When the Union soldiers were informed of the surrender, most of them refrained from cheering. A Confederate newspaper concluded that the Union army exercised restraint because the citizens of Vicksburg had surrendered not to them but to famine.

Like most Civil War battlefields, Vicksburg National Military Park is inhabited by the spirits of soldiers whose devotion to their duty and to their country will not let them rest. For years, the citizens of Vicksburg have claimed that the ghost of General Ulysses S. Grant rides through the battlefield at midnight. Some tourists have detected the lingering odor of gunpowder and smoke on days when Civil War reenactments were not held at the battlefield. The boom of cannon fire has been heard across the battlefield. Visitors have reported hearing other ghostly sounds as well, such as the screams of wounded men and horses and the shrill voices of long-dead officers still issuing commands.

The website the Haunted Traveler includes a bizarre experience that a Civil War buff named Jim Wilson had

at the park. Wilson said he was walking in the area where a Confederate stronghold had repulsed an attack by Union forces. More soldiers had died in this one area than in any other part of the battlefield. Wilson was walking around when a wall of fog measuring thirty yards long and ten yards wide drifted out of the nearby woods to the east. He said that the fog, which was moving against the wind, followed the same route that the Union soldiers took when they charged the Confederates. The fog dissipated at the site of the Confederate stronghold.

A friend of Wilson's who worked at the casino had a similar experience near the Vicksburg National Cemetery. He had just finished his shift and decided to let off steam by

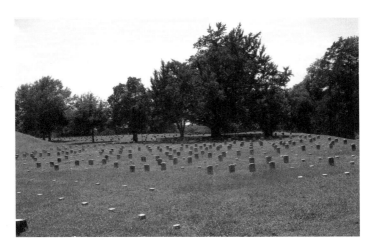

Vicksburg National Cemetery.

jogging around the cemetery. He had not gone far when he saw a cloud of fog hovering about a foot or so above several of the graves. The fog was not visible in any other part of the cemetery. The young man was so frightened that he cut his evening run short and returned home.

Specific monuments are said to be the favorite haunts of the battlefields ghosts. One of the most enduring of the battlefield's ghost legends concerns the Pennsylvania State Memorial. It is also known as the Five Faces because of the five bronze medallions on the front of the memorial. Each medallion is engraved with the likeness of one of the Pennsylvania unit commanders. Some people say that if you go to the Pennsylvania State Memorial at night and shine your flashlight on the medallions, the eyes will blink. According to another variation of the legend, blood trickles from the eyes during thunderstorms.

The Illinois Monument is also said to be haunted. Many people have reported seeing the ghosts of soldiers walking around the monument, usually in the area of the Third Louisiana Redan. In the mid-2000s, a team of paranormal investigators had an unsettling experience at the Pennsylvania State Memorial and at the Illinois Memorial. They were standing in front of the semicircular marble walls staring at the five medallions when one of the members became violently ill. The team members climbed back into their car and drove to the Illinois Memorial. They were walking around the memorial, collecting EMF

The Pennsylvania State Memorial at Vicksburg National Military Park.

readings, when another person doubled over in pain. Later, the leader of the group attributed the illness of his members to the large amount of spiritual energy that registered on the group's EMF detectors.

In *The Ghost Hunter's Handbook*, author Troy Taylor says that battlefields are ideal locations for hauntings because of the sudden loss of life that occurred there. Because many soldiers "did not even know what hit them" when they died, their spirits are confused, uncertain about whether they are alive or dead. Taylor goes on to say that residual hauntings are common on battlefields,

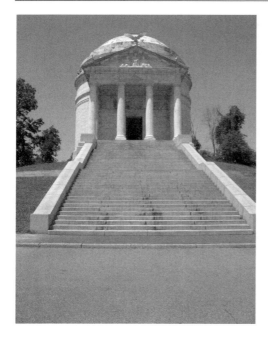

The Illinois Monument at Vicksburg National Military Park.

where episodes from the conflict play out over and over again. One can only hope that the phantoms that do not realize they have been killed and are wandering aimlessly over the battlefield constitute a small percentage of the hauntings at Vicksburg National Military Park.

THE CORNERS MANSION

The Corners Bed-and-Breakfast Inn is located at 601 Klein Street. The story goes that the current owners, Cliff and Betty Witney, discovered the old house purely by accident. While they were traveling to Washington, D.C., from Texas, the couple got sidetracked and ended up in Vicksburg. While they were spending the night at Cedar Grove Mansion, Betty noticed that the charming house across the street was for sale. She and Cliff found out that after the last member of the family who built the house died during the Great Depression, the house served as an apartment house and duplex. In 1959, Dr. Robert and Susan Bonham Ivy purchased the house for $8,000. The Ivys spent at least $50,000 restoring the house to its 1870s appearance. Betty fell in love with the old house and convinced her husband to buy it. The Witneys filled the old house with antiques and converted it into one of the city's most popular bed-and-breakfasts. According to a tale told

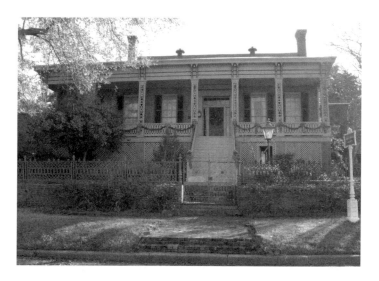

The Corners Mansion.

by two of their guests, one of the original inhabitants seems to be reluctant to part with her beautiful home.

The Corners Mansion was built in 1873 by John Alexander Klein as a wedding present for his oldest daughter, Susan, and her new husband, Isaac Bonham. Mr. Klein also built Cedar Grove Mansion across the street. The front entrance is clearly Greek Revival. Italianate features can be found in the cast-iron cornices over the windows and in the supports under the eaves. The handmade pierced columns, which are unique to Vicksburg, are engraved with the standard nineteenth-century symbols of love and marriage: hearts,

rings, diamonds and shamrocks. The ring and diamond motifs can also be seen in the layout of the brick walkways. The iron fence was transported to Vicksburg from Pennsylvania. The gardens are landscaped in the original design. These French-Créole parterre gardens are so distinctive that they were taken into consideration when the decision was made to list the Corners on the National Register of Historic Places. The bricks, which were made locally, are soft because they were fired at low temperatures.

One would suppose that Isaac and Susan would have been perfectly happy in their splendid new home. Unfortunately, that was not the case. One of their two sons, Archibald, died of malaria in 1882 at the age of five. The next year, Isaac was killed in a saloon on Washington and Clay Streets. He was attempting to break up an altercation between two of his friends and was accidentally shot. In 1884, Isaac and Susan's older son, John, also died of malaria at the age of nine. Tragedy struck Susan a second time that same year when her father, John Alexander Klein, passed away at the age of seventy-two. Unable to remain in the house that reminded her of her loved ones who were no more, Susan spent most of her time with her mother at Cedar Grove. After Susan's mother died in 1909, she sold the Corners and Cedar Grove and moved to her sister's house, where she lived until her death in 1935.

Ghost lore records hundreds of cases where houses are haunted because of the excessive amount of misery endured by the owners. For example, the Lemp Mansion

in St. Louis, where four members of the Lemp family committed suicide, is generally considered to be one of the most haunted houses in the Untied States. Employing the same line of reasoning, one would expect the Corners to be equally haunted. This, however, is not the case. In fact, only one ghostly encounter has ever been reported. Back in the early 2000s, a couple of women booked a room at the bed-and-breakfast. They had just returned to the old house from a day of sightseeing and dining and had just entered the hallway when they noticed a woman wearing a dress from the Victorian era walking ahead of them. The guests tried to get the woman's attention, but she continued walking down the hall. When she reached the back door, the mysterious figure simply passed through it. The two women were so terrified by their experience that they checked out of the Corners at ten thirty that evening.

Paranormal researchers would probably categorize the appearance of this particular apparition as a residual haunting because the ghost seemed to be oblivious to the presence of the two women. If the apparition is the ghost of Susan Bonham, it could be that she was so preoccupied that she did not even notice the strange women in her house. After all, Ms. Bonham did have a lot on her mind before she died.

LAKEMONT

Judge William Lake was born near Cambridge in Dorchester County, Maryland, on January 6, 1808. In 1827, Lake graduated from Jefferson College in Pennsylvania with a major in classical studies. When he was twenty-three years old, Lake was elected to the Maryland state legislature. After moving to Vicksburg a few years later, he was admitted to the bar in 1834 and began practicing law. In the early 1830s, Lake built a beautiful Greek Revival home at 1003 Main Street for himself and his beloved wife, Anne. In 1848, Lake was elected to the Mississippi state senate. Running as a candidate for the American Party, Lake was elected to the Thirty-fourth Congress from March 4, 1855, to March 3, 1857. Two years later, in 1859, he was elected to a two-year term in the state House of Representatives. When Judge Lake was not serving in the state capital of Jackson, Mississippi, he was practicing law in Vicksburg.

Lakemont.

After Mississippi seceded from the Union on January 9, 1861, Judge Lake decided to campaign for the Confederate Congress that same year. The judge's fateful decision had consequences that continue to resonate in his beautiful home to this day.

On October 15, 1861, Judge William Lake left his law office and walked home for lunch, just as he did every day. After his meal, he took his afternoon nap. An hour later, he awoke from his nap. He straightened his clothes, kissed his wife and walked out the front door. Nothing in his demeanor suggested to her that this day was different from countless others. It was, though. Instead of returning to his office, Judge Lake walked down to the Mississippi, where a small boat awaited him. He then made his way to a sandy strip of

land on the Louisiana side of the river called Desoto Point. The Point had become a favorite dueling ground because it was outside of Mississippi, where dueling was illegal, and it was miles from any Louisiana town, making arrest by Louisiana officers very unlikely. His opponent was Colonel Chambers of Mississippi, a political rival of Judge Lake's.

Not long before the judge and Colonel Chambers received their dueling pistols from their seconds, Mrs. Lake learned from her servants that her husband was about to be involved in a duel on Desoto Point. She grabbed her spyglass, and in her hurry to run upstairs, she knocked over a bottle of perfume that the judge had brought her from New Orleans. The perfume spilled on the dresser and pooled on the floor. Standing on the second-floor veranda with her opera glasses in hand, Mrs. Lake saw the two men walk twelve paces, turn and fire. After the smoke cleared, her husband lay on the ground. His second, Captain Leathers, cradled the judge in his arms while the surgeon examined him. Hypnotized by the horror of the scene, Mrs. Lake saw the surgeon shake his head. The poor woman cupped her face in her hands and moaned, over and over again, "Oh God! Oh God!" Mrs.Lake never fully recovered from her husband's death. She went to Alabama to live for a while but eventually returned to Lakemont, where she died.

This melodramatic version of the death of Judge William Lake is the one that people still tell in Vicksburg. However, according to records kept in Fisher Funeral Home, the duel was

held, not within view of his wife, but at Hopewell, Arkansas, opposite Memphis, Tennessee. His body was brought back to Vicksburg, and he was buried at City Cemetery. Lakemont was purchased by a local grocer named B. Cocarro in 1900. In 1916, the top story of the house was destroyed in a fire. In 1973, a young businessman named Wayne Jabour and his wife, Becky, bought the old house from the Cocarros' heirs. For years, former occupants of the house said that Anne's ghost walked in her garden, just as she had done for years after her husband died. They also claimed to have heard the rustling of her skirts on the porch and to have smelled her jasmine perfume. The Jabours did not live in their house long before they discovered that Lakemont really was haunted.

In an interview with Sylvia Booth Hubbard, Becky Jabour said that the real estate agent told her after she and Wayne closed on the house, "You know, you have a ghost." Sure enough, she and her husband heard the swish of skirts and smelled Mrs. Lake's jasmine perfume, usually in October, the month of her husband's death. However, the Jabours became convinced that Lakemont was haunted when they opened their house to the public for Pilgrimage tours in 1978. The first morning of the tours, Becky was guiding people through the house when she heard a loud crash. At first, she thought that a large platter had fallen off a table. Neither the platter nor anything else was out of place. She returned to the parlor, where she had left her guests, and glanced up at the 1790 Federal mirror. To her dismay, she noticed that the Federal mirror hanging on the wall was cracked from side to

side. At first, Becky thought that Mrs. Lake disliked having tours in her home. Later, she concluded that Judge Lake's widow simply wanted to make her presence known.

Strange disturbances continued within Lakemont after the tours. Becky said that she has felt a cool breeze wafting through the house on days when the windows are closed. She has also heard footsteps walking up and down the stairs when no one is there. Books tend to fall out of a certain cabinet. One day, while guests were in the house, the door to the linen closet opened by itself. Because liquor was kept in the house, her guests interpreted the strange occcurence as a sign that it was time to start serving drinks. Becky also said that before the upper story of the house burned in 1916, the lady she bought the house from said that every night she heard a thumping sound in a wall of the main bedroom on that floor. Becky told author Jim Longo that one night when she was reading, the bedroom door opened by itself. She also said that one day she was talking to a visitor sitting on a sofa, facing her, when all of a sudden all of the blood drained from the visitor's face. The woman told Becky that she had just seen a hazy figure standing at the door to the room. She described the woman as wearing a dark coat with white ruffles at the collar. A thorough search of the house revealed that no one else was there.

Becky said that the "perfume ghost," as Mrs. Lake's ghost came to be known, was never a menacing presence. Over the years, the Jabours accepted Mrs. Lake's apparition as a member of the family. In fact, her children viewed Mrs. Lake as a guardian angel who shared their love for Lakemont.

BIBLIOGRAPHY

BOOKS

Alderman, Edwin Anderson, et al. *Library of Southern Biography*. New Orleans: Martin and Hoyt, 1907–23.

Asfar, Dan, and Edrick Thay. *Ghost Stories of the Civil War*. Edmonton, Canada: Ghost House Books, 2003.

Ballard, Michael B. *The Campaign for Vicksburg*. Fort Washington, PA: Eastern National, 2007.

Brown, Alan. *Haunted Places in the American South*. Jackson: University Press of Mississippi, 2002.

Callon, Sim C., and Carolyn Vance Smith. *The Goat Castle Murder*. Natchez, MS: Plantation Publishing Company, 1985.

Groom, Winston. *Vicksburg, 1863*. New York: Alfred A. Knopf, 2009.

Hauck, Dennis William. *Haunted Places: The National Directory*. New York: Penguin Books, 1996.

Hubbard, Sylvia Booth. *Ghosts! Personal Accounts of Modern Mississippi Hauntings*. Brandon, MS: QRP Books, 1992.

Kempe, Helen Kerr. *The Pelican Guide to Old Homes of Mississippi.* Vol. 1, *Natchez and the South.* Gretna, LA: Pelican Publishing Company, 1989.

Roth, Dave, ed. *Blue and Gray Magazine's Haunted Places of the Civil War.* Columbus, OH: Blue and Gray Enterprises, 1996.

Turnage, Sheila. *Haunted Inns of the Southeast.* Winston-Salem, NC: John F. Blair: 2001.

Windham, Kathryn Tucker. *13 Mississippi Ghosts and Jeffrey.* Tuscaloosa: University of Alabama Press, n.d.

WEBSITES

Americantowns.com. "Old Court House Museum of Vicksburg." http://www.americantowns.com/ms/vicksburg/organization/old_court_house_museum_of_vicksburg.

Anchucamansion.com. "Anchuca Historic Mansion and Inn." www.anchucamansion.com/index.shtml.

Bed and Breakfast 411. "Anchuca Historic Mansion & Inn: Vicksburg, Mississippi." www.bnb411.com/mississippi/bed_and_breakfast_info.asp?id=115.

Bed and Breakfast Inns of North America. "1092-8 Stained Glass Manor-Oak Hall." www.inntravels.com/usa/ms/stainedglass.html.

Thecabinet.com. "Dark Destinations." http://thecabinet.com/darkdestinations.location.php?sub_id=dark_destinations&letter=m&1.

Cedar Grove Mansion Inn & Restaurant. "Cedar Grove History." www.cedargroveinn.com/history.php.

Thecorners.com. "The Corners Mansion Bed & Breakfast Inn: History." www.thecorners.com/history.html.

Creativespirits.net. "McRaven House." www.creativespirits.net/paranormal/ghost-definitions/mcraven-house.

Downing, Mrs. George. "History of Christ Episcopal Church." www.christcurhchvburg.dioms.org/about/history.html.

"Duff Green Mansion." www.stofthelongeststuffatthelongest domainnameatlonglast.com.

"Duff Green Mansion History." www.duffgreenmansion.com.

Facebook.com. "Duff Green Mansion Investigation Reports." http://ruru.facebook.com/topic.php?uid=141742583838&topic=13133.

Find a Grave. "Browse by City: Vicksburg." www.findagrave.com/php/famouse.php?=city&FScityid.

Geniecorner.com. "McRaven House Vicksburg, Warren County, Mississippi." www.geniecorner.com/HTML/McRaven.html.

Ghostinmysuitcase.com. "Baldwin House Restaurant." www.ghostinmysuitcase.com/places/baldwin/index.htm.

———. "Duff Green Mansion." www.ghostinmysuitcase.com/places/duffgreen/index.htm.

HauntedHouses.com. "Anchuca Mansion." www.hauntedhouses.com/states/ms/anchuca.cfm.

———. "Cedar Grove Mansion." www.hauntedhouses.com/states/ms/cedar_grove_mansion.cfm.

Haunted Places to Go.com. "Vicksburg's Haunted House: The McRaven Home." www.haunted-places-to-go.com/haunted-house-2html.

The Haunted Traveler. "Explore Haunted Mississippi." www. haunted/traveler.com/haunteed_mississippi.htm.

Mezensky. "The McRaven House." Suite101.com. www.suite101. com/article.cfm.civil_war_ghosts/66354.

National Park Service, U.S. Department of the Interior. "Pemberton's Headquarters." www.nps.gov/vick/.../ pembertons-headquarters.htm.

Oldcourthouse.org. "Vicksburg's Old Court House Museum." http://oldcourthouse.org.

Paranormal News. "Ghosts: Field Report of Duff Green Mansion in Vicksburg, Mississippi." www.paranormalnews. com/article.asp?articleid=461.

The Political Graveyard. "Politicians Killed in Duels." http:// politicalgraveyard.com/death/duels.html.

Rent, Jeff. "Field Reports from Baldwin House." Unexplained Files. www.unexplainedfiles.com/2003/04/field-reports-from-baldwin-house.html.

Southern Lagniappe. "Welcome to Southern Lagniappe." http://southernlagniappe.blogspot.com/2009/10/vicksburg-tresure-old-court-house.html.

Southpoint.com. "Old Court House Museum, Vicksburg-Mississippi." www.southpoint.com/states/ms/vburg/oldcourt.htm.

StoppingPoints.com. "Pemberton Headquarters." www.stopping points.com/mississippi/Warren/Pemberton+Headquarters.html.

Storycook Favorites. "Storycook Favorites and the BB Club." www.storycookfavorites.com/Index~ns4html.

The Time Capsule of the South. "Welcome to McRaven Tour Home." www.mcraventourhome.com/Hauntings.asp.

Vicksburg Bed and Breakfast Association. "Tapestry: A Living History of Vicksburg." www.visitvicksburg.com.

Vicksburg, Mississippi's Historic B&B Inn. "1902–08 Stained-Glass Manor Oak Hall." www.vickbnb.com.

Weaver, Gabe. "John Pemberton." www.sonofthesouth.net/leefoundation/john-clifford- pemberton.htm.

White, Jack, and Toni White. "Visit Vicksburg and Natchez and Be Soothed by Southern Spirits." www.sealetter.com/Feb-02/miss.html.

Wikipedia. "William A. Lake." http://en.wikipedia.org/wiki/William_A._Lake.

MAGAZINES

Sullivan, Charles. "The Haunting of McRaven." *Mississippi* (September/October 1989): 22+.

INTERVIEWS

Gorney, Jim. Personal interview, January 20, 2010.

Smollen, Shirley. Personal interview, July 18, 2009.

Tuminello, Skip. Personal interview, May 20, 2009.

ABOUT THE AUTHOR

Alan Brown was born in Alton, Illinois. After attending Millikin Univeristy, Southern Illinois University and the University of Illinois, he taught high school in Springfield, Illinois. In 1986, he began teaching English at the University of West Alabama. After living in Mississippi for a year, Brown became interested in the folklore of the South and began collecting it on his own. "People talk in the Midwest," Brown said, "but not like they do in the South. I guess this is why southerners are great storytellers." When he is not teaching freshman composition or American literature, Dr. Brown writes books on his favorite topic: ghost stories. Haunted Vicksburg is his eleventh collection of southern ghost tales. As much as he loves old stories that send shivers up the spine, Brown's first love is his wife, Marilyn, and their two daughters, Andrea and Vanessa.